Debra J. DeWitte
University of Texas at Arlington

Ralph M. Larmann
University of Evansville, Indiana

M. Kathryn Shields

GATEWAYS TO ART

Journal

for Museum and Gallery Projects

THIRD EDITION

Student name, Institution:

Raigan
Muldrow

Thames & Hudson

Gateways to Art Journal
© 2015 and 2018 Thames & Hudson

Text © 2015 and 2018 Debra J. DeWitte,
Ralph M. Larmann, and M. Kathryn Shields

First published in 2015 in paperback in the United States of America by Thames & Hudson Inc., 500 Fifth Avenue, New York, New York 10110

www.thamesandhudsonusa.com

Library of Congress Control Number 2015936444

ISBN 978-0-500-84131-0

Designed by Michael Johnson

Printed and bound in Slovenia by DZS-Grafik d.o.o.

Illustration Credits

All images are listed by illustration number.

Front cover
Diego de Silva y Velázquez, *Las Meninas, c.* 1656. Museo Nacional del Prado, Madrid, Spain

Contents

How to Use this Journal

When you visit a museum or gallery, you will be surrounded by a wealth of artworks. While you will find much that will inspire you, there will also be too much to absorb in a single visit. This journal aims to help you get the most out of your time at the museum by focusing your attention on what you see. This will help you to gain a better understanding of specific works and identify related or contrasting works in the museum's collection.

Start by reading the guidelines given in "Planning Your Visit" (pp. 4–5). Then work through each page of this journal.

The opening section on "Representational, Non-Objective, Abstract" will introduce you to the ways in which subject matter has been depicted.

The "Visual Analysis" (pp. 8–23) section will introduce you to the elements and principles of art and help you understand how they have been applied to the artworks you see in front of you.

A section on "Media" (pp. 24–31) concentrates on the materials and techniques artists use. One of the best things about going to see artworks up close is that you can really appreciate how much work went into creating each one, and how the artist went about his or her craft.

In the section on "Modes of Analysis" (pp. 32–33) you can focus on understanding the content of a work. This section encourages you to think about different ways you could interpret what is in the artwork.

Any museum or gallery is a rich source of historical information, and the "History and Culture" section (pp. 34–35) offers advice on what to look out for when you are there. The people who have created the displays will already have done a lot of thinking for you, grouping works together in certain ways to help you get a better grasp of different influences and periods of art history.

The "Theme" section (pp. 36–37) will guide you to recognize important ideas and emotions that have inspired artists all over the world and all through time to express themselves through art. It is fascinating to compare how a particular theme can be depicted in so many different ways.

Finally, the section on "Understanding What Museums Do" (pp. 38–52) is designed to take you behind the scenes at a variety of museums, so that you will be prepared for your own visit. As you will see, no two museums are the same; like people, museums have their own identities and profiles. Each offers different facilities to help you with your project. Finding out in advance about your local museum and how you can benefit from its services will make your time there all the more enjoyable.

Planning Your Visit

Museums are storehouses for our cultural treasures. Some focus on specific periods and cultures. Galleries frequently change the artwork they display, and offer special exhibitions showcasing the work of contemporary and local artists. Artworks in a gallery are often for sale, but works owned by a museum are held in its care long term. Ask your professor which museums and galleries in your area she or he would recommend.

Often, museums were built by renowned architects, and are therefore works of art in themselves (1). As museum staff take pride in their collections, and are concerned for the valuable objects in their care, museums often have strict rules. The architecture itself can also be somewhat forbidding. Don't let such rules, or a building's imposing **facade**, make you feel unwelcome. Remember that the artwork is being displayed for you.

Let yourself wander through the museum, stopping to consider works that intrigue you. Everyone's taste is unique, and it is better to focus on a few works than to overwhelm yourself trying to understand the museum's entire collection in one day. When you come upon an artwork you would like to write about or sketch, stop and consider what it is that drew you to it. Do you love it? Hate it? Do you find it beautiful or ugly? Are you curious about the characters in the scene? Or are you confused by what the artist is trying to say? Use the textbook, class notes, and

1 Cleveland Museum of Art, Ohio

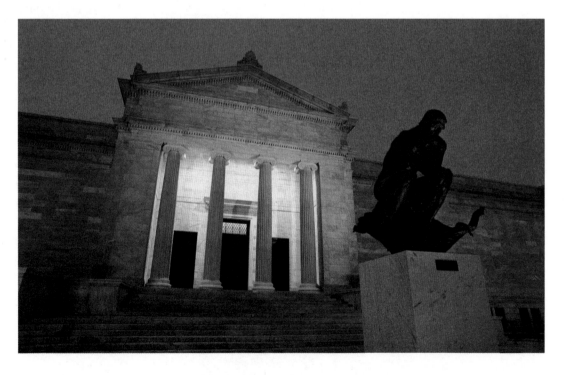

museum labels to help you understand the artwork. But do not forget to take ample time to look at the artwork in detail. This journal will help you to do this.

You can make the most of your visit to a local art museum or gallery if you plan ahead. Based on what your teacher advises, choose a museum to visit. Research the items in the table below online before you go so that you can make the most of your time with the exhibits.

General Museum Information

What to Take with You

- ☑ Your assignment
- ☑ This journal
- ☑ Pencils (and pens, if allowed)

While You Are There

Museum and gallery projects often require you to study one work in detail, or to compare and contrast two works. The experience of seeing works in a museum or gallery is the best way to enjoy and learn about art. Artworks displayed in the same room may well be by the same artist, or from the same era or culture. You may notice something in these pieces that will inspire extra ideas for your assignment. As you notice aspects of your chosen work of art, consider why the artist made the choices he or she did.

Artwork labels: There are usually labels next to each artwork. These labels contain useful information about the work. Do not forget to make notes of the details given in the labels. The museum bookstore and website may also have more material about the artwork you select.

Museum and Gallery Dos and Don'ts:

You may want to get close to a work to study a particular detail, but remember to be courteous to other visitors who want to view the work at the same time. Never touch a work of art, because doing so can damage it. Do not take photos unless you are sure this is allowed. If in doubt, ask. Some museums permit visitors to take photos if flash is not used. Finally, although food and drink are not allowed in the exhibition spaces of museums and galleries, many have a café or restaurant.

Museum name	
Admission charge	
• Does the museum offer a reduced entry price for students? • Does the museum charge for entry to temporary exhibits? • Does the museum offer free or reduced admission prices on certain days?	
Opening hours	
Travel information	
• Does the museum charge for parking? • What public transportation is available?	
Gallery rules	
• Are backpacks and cameras allowed in the galleries? If not, is there somewhere to check these? Is there a charge?	

Looking at Art

Representational, Non-Objective, Abstract

As a first step in considering the content of a work, decide whether it is representational or non-objective. A representational work depicts objects or people in such a way that we can recognize them (**2**). A non-objective work depicts subject matter that is not recognizable as an object or people (**3**).

Both representational and non-objective art can, to some degree, be abstract. Abstract means literally to extract something or to emphasize it. In art this means that artists can emphasize, distort, simplify, or exaggerate the formal (visual) elements of a work.

When you encounter a work of art, ask yourself whether the artwork you are studying has been abstracted, and if so, to what degree. Is the thing the artwork represents still to some extent recognizable? The nkisi shown in **figure 2** is recognizable as a person and is therefore representational, but it is more abstract than sculptures from ancient Greece (for example, see the *Riace Warrior* sculpture in **42**, p. 28).

The red-and-purple sculpture shown on this page is even more abstracted (**4**). Yet although it appears to be completely non-objective, it is not entirely unrecognizable once the title *Batman* makes it identifiable to us.

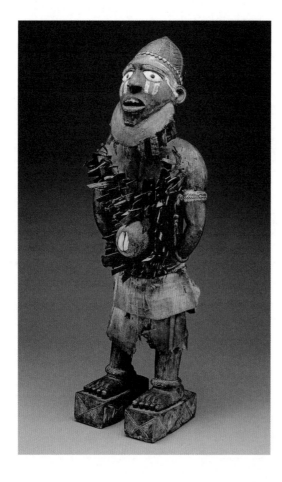

2 Standing power figure (*nkisi nkondi*), late 19th century. Wood, iron, raffia, ceramic, kaolin pigment, red camwood powder (tukula), resin, dirt, leaves, animal skin, and cowrie shell, 43¾ × 15½ × 11". Dallas Museum of Art, Texas

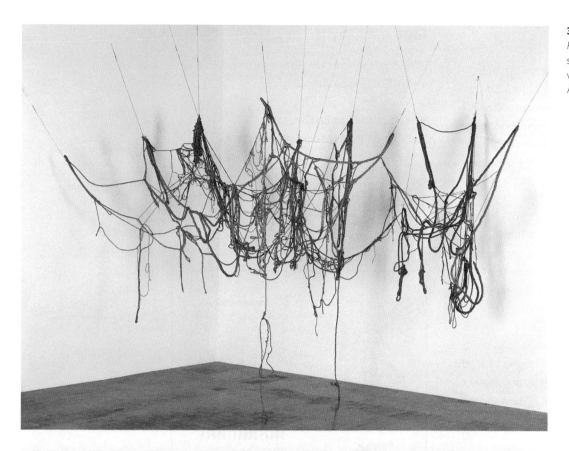

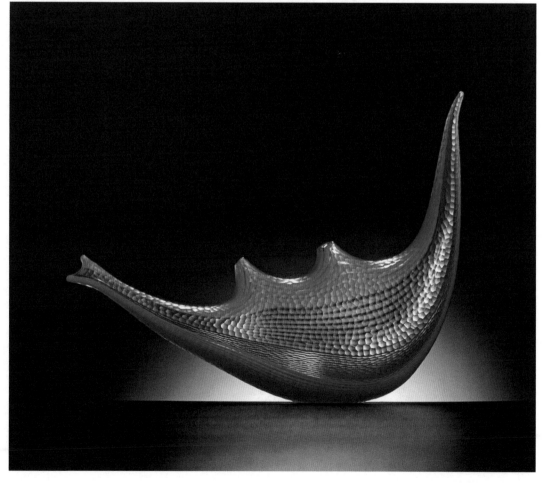

4 Lino Tagliapietra, *Batman*, 1998. Glass, 11½ × 15½ × 3½"

Visual Analysis

A work of art is the product of the dynamic interrelationships between the various art **elements** and **principles** as they are utilized by the artist. All of these elements and principles can be used by artists in both **two-** and **three-dimensional** works of art, although often in different ways.

As you engage with a work of art, ask yourself why the artist made such choices. In two-dimensional works (such as paintings, drawings, and prints), see if you can determine how an artist created the impression of three-dimensionality.

By looking more closely at artworks and trying to identify the elements and principles of art that have been used to create them, we may further understand the artist's intended vision and will notice how the artwork often reflects the time and place from which it came.

Line

How does the artist use **line** in your chosen artwork? Consider the following:

- **Actual** and **implied** lines (**5**)
- What do the lines communicate (**6**)?
- Are the lines regular or irregular?
- Do the lines express any emotions?
- Do the lines direct your eye through the work?

Shape

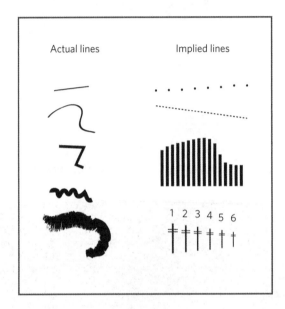

5 Actual and implied lines

6 Communicative qualities of line

Vertical lines communicate strength, stability, and authority

Horizontal lines communicate calm, peace, and passiveness

Diagonal lines communicate movement, action, and drama

How does the artist use **shape**? Consider the following:

- **Geometric** and **organic** shapes (**7**)
- Implied shapes (**8**)
- **Positive** and **negative** shapes (**9**)

7 Geometric and organic shapes

8 Implied shapes

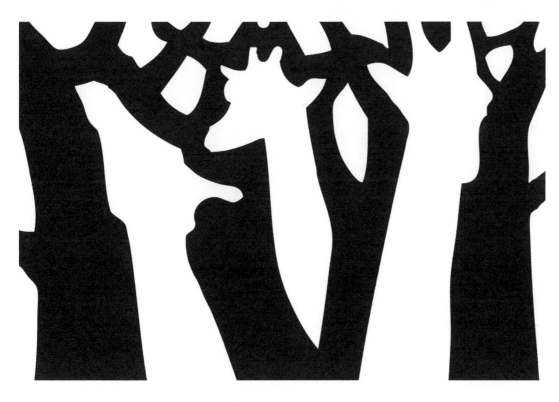

9 Positive and negative shapes are created using the principle of contrast. Combining the two creates figure–ground reversal. The background can become the figure, and the figure can become the background

Form

Did the artist choose geometric or organic **form**, or a combination of both?

Is the work a freestanding one that can be viewed from all sides ("**in the round**")?

Artists take into account how light falls on an object. When observing a three-dimensional work, ask yourself how the light affects the appearance of the work of art. Is the object in the location it was made for (*in situ*)? If not, does the lighting in its current location support or hinder the work?

If the work is a sculpture, is it carved with very little depth ("**bas-relief**"), or is it a carved panel where the figures project with a great deal of depth from the background ("**high relief**")?

Volume and Mass

How has the artist used **volume** or **mass** (**10**)?

Is the work's volume closed or open (**11**)?

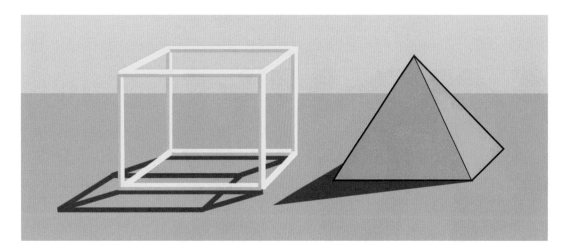

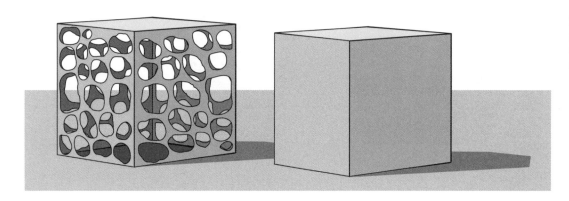

Texture

Is the **texture** of the object smooth or rough (**12**)? (If a two-dimensional work, is the surface smooth or is there texture created by the brushstrokes?) How would you describe it? Is it something you would want to touch? (Don't actually touch any work of art in a museum.)

Does the work have any actual texture, or is its texture **implied**, that is, experienced solely from an illusion created by the artist and our memory of how the surface shown in the work would feel?

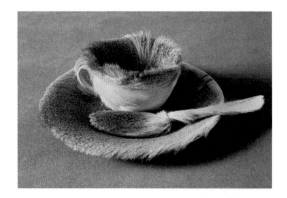

Value

Are there any significant **value** changes (i.e. changes in the degrees of lightness and darkness) in the work? If so, why did the artist use value in this way(**13** and **14**)?

Does the artist use **hatching** or **cross-hatching** to create value (**15**)?

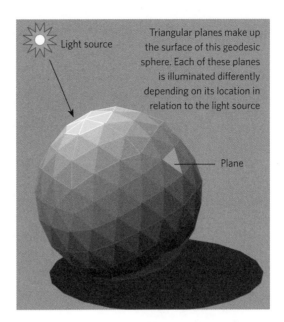

Light source

Triangular planes make up the surface of this geodesic sphere. Each of these planes is illuminated differently depending on its location in relation to the light source

Plane

13 Values and **planes** of a geodesic sphere, vector graphic

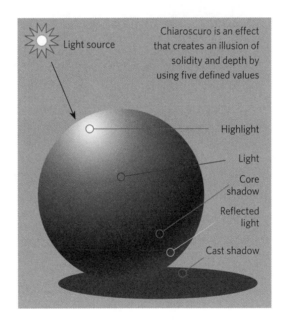

Light source

Chiaroscuro is an effect that creates an illusion of solidity and depth by using five defined values

Highlight

Light

Core shadow

Reflected light

Cast shadow

14 Diagram of chiaroscuro

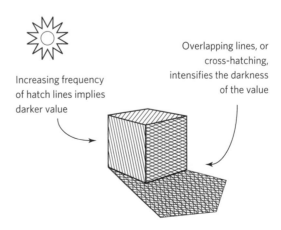

Increasing frequency of hatch lines implies darker value

Overlapping lines, or cross-hatching, intensifies the darkness of the value

15 Creating value using hatching and cross-hatching

Space and Implied Depth

Consider any techniques the artist uses to create a sense of depth, or the illusion of three-dimensions, in a two-dimensional work of art. For example:

- Size, overlapping, and position.
- Alternating value and texture.
- Brightness and color.
- Use of **atmospheric perspective** (**16**).
- **Isometric** perspective (**17**).
- **Linear** perspective (**18**).
- Light.

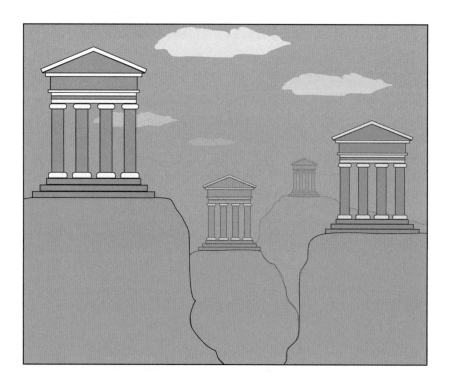

16 The effects of atmospheric perspective

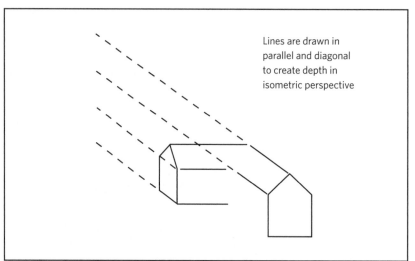

17 Graphic detailing isometric perspective

Lines are drawn in parallel and diagonal to create depth in isometric perspective

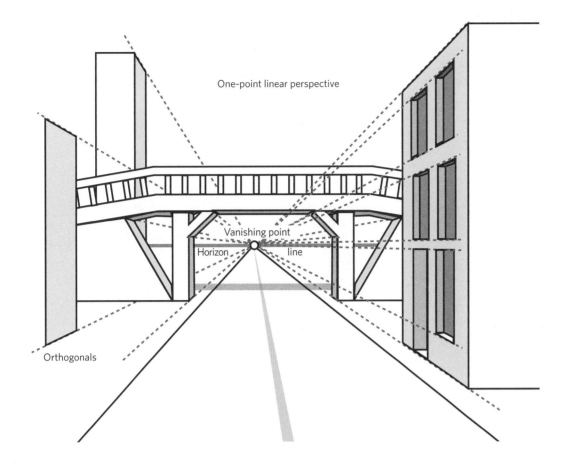

One-point linear perspective

Vanishing point

Horizon ○ line

Orthogonals

How has the artist created the illusion of light within the scene? Does the light solely imitate reality or does it hold symbolic meaning (knowledge, spirituality, *etc.*)? What is the effect of light? The single overhead ceiling light in Carrie Mae Weems's "Untitled (Woman and Daughter with Makeup)" creates an intimate atmosphere, highlighting a private scene between mother and daughter (**19**). The central position of the light in the image also creates a sense of space by emphasizing the converging lines of the edge of the table.

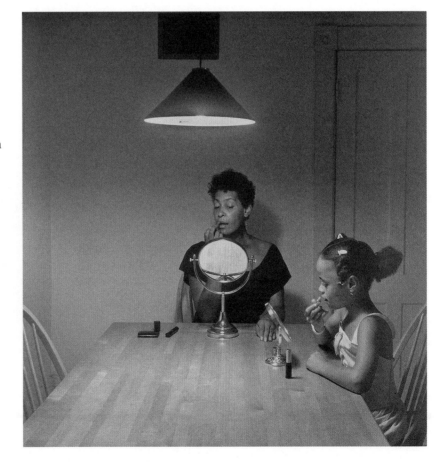

19 Carrie Mae Weems, "Untitled (Woman and Daughter with Makeup)," 1990, from *Kitchen Table* series, 1989–90. Inkjet print, 41¼ × 41¼ × 2¼" (framed)

Color

Color is an important element of many artworks. Look carefully at the ways in which the artist uses color, for example:

Refer to the color wheel and note what **hues** the artist uses. Is the artwork **monochromatic** or does it use many hues (**20**)?

Are the colors **saturated** (do they have a high chroma) (**21**)?

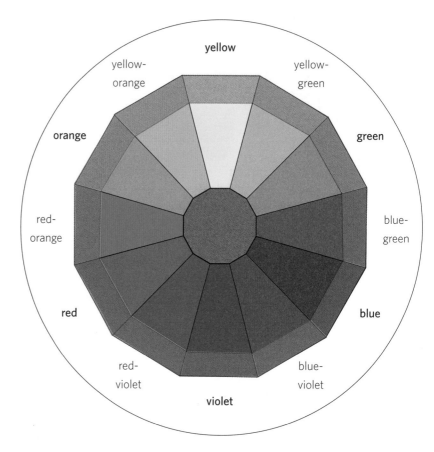

20 Traditional twelve-step color wheel using "artist's colors"

21 A sampling of chroma, tone, shades, and tints in green hue

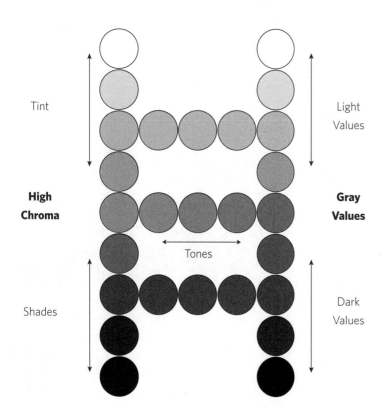

Examine the use of colors to see whether they are **analogous** or **complementary** colors (**22**). Are the colors warm or cool?

Do you notice any visual effects, such as **optical** color mixing (**23**)?

Finally, think about the psychological and expressive effects of color in the artwork. Do the colors elicit an emotional response from the viewer, or express the emotions of the artist?

Primary/secondary analogous combinations

Primary/secondary, and tertiary complements

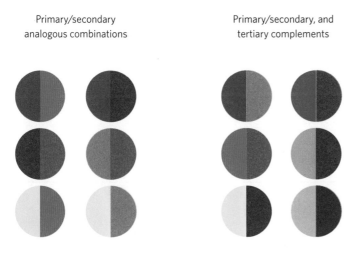

22 Color combinations and complements in pigments

23 Two squares, one filled with red and blue dots and the other with red and yellow dots, to create optical color-mixing effect. The first mixture looks like purple, while the second blends to orange

Time and Motion

Does the artwork in some way communicate the passage of time? For example, it may tell a story or narrate a series of events. If the artwork you have chosen is in such a **medium** as film or video, the passage of time may be an important aspect of the artwork, but even static artworks can involve the passage of time.

Now consider whether the artwork involves **motion** in any way. Remember that even a static artwork, such as a painting, drawing or sculpture, can express motion.

If the work is static, is motion implied, or does the work convey an illusion of motion?

If your chosen artwork is a film or video, a **happening** or a **performance**, time and motion are essential aspects of the work.

Finally, consider whether the work involves actual motion (in other words, is it a **kinetic** work of art)? Notice any moving parts and ask yourself why the artist chose motion as a significant aspect of the work.

Unity

Does the artwork express a carefully controlled order or wholeness (i.e., did the artist express **unity** in the work), or, in contrast, is it disordered or even chaotic (intentionally lacking in unity) (**24**)?

Consider aspects of the work that express unity (or its opposite, disunity). For example, are similar aspects of the **composition** repeated throughout to create visual harmony (**25**)?

Is there a unifying conceptual aspect to the work? For example, do its different aspects all relate to an overall idea or emotion, such as liberty, justice, or happiness?

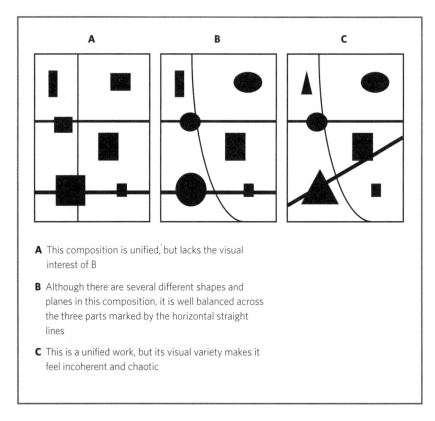

A This composition is unified, but lacks the visual interest of B

B Although there are several different shapes and planes in this composition, it is well balanced across the three parts marked by the horizontal straight lines

C This is a unified work, but its visual variety makes it feel incoherent and chaotic

24 Three diagrams of compositional unity

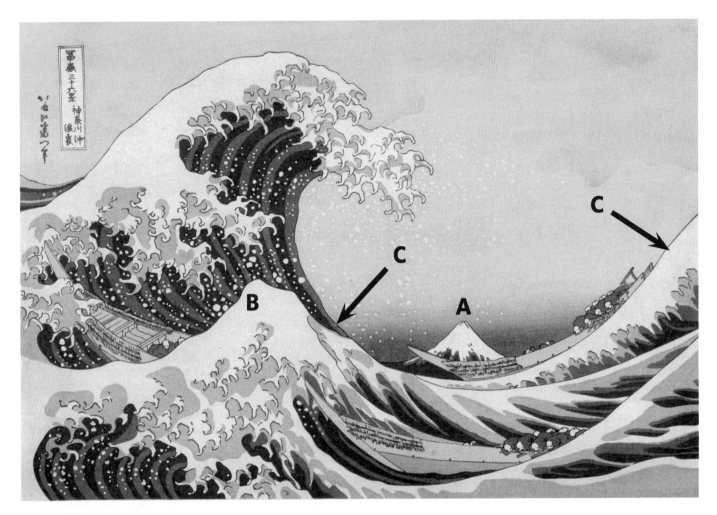

25 Katsushika Hokusai, "The Great Wave off Shore at Kanagawa," from *Thirty-Six Views of Mount Fuji*, 1826–33 (printed later). Print, color woodcut. Library of Congress, Washington, D.C.

 A Mount Fuji almost blends into the ocean

 B Whitecaps on the waves mimic the snow on Mount Fuji, creating a sense of the mountain's presence throughout the scene

 C Solid shape of the great wave curves around the deep trough below it, uniting the two areas

Variety

What aspects of the artwork give it **variety** (**26**)?

Consider value, texture, color, shape, and other elements of art.

What effect does the variety have on the viewer: does it suggest unity or a lack of unity?

26 Variety of shapes and values set into a grid

Balance

Examine the artwork for any elements that give it balance: are the same or similar elements repeated throughout the work, or do elements of similar visual weight **balance** one another out? It will be helpful to see if you can detect symmetrical, asymmetrical, or radial balance.

To determine whether the artwork is symmetrically balanced, imagine that a line divides it horizontally or vertically into two equal parts. Can you see any elements that are repeated on both sides of the line?

If the artwork is not symmetrically balanced, it may be that the artist used elements of different visual weight to achieve balance. For example, is a large figure or object on one side of an imaginary dividing line balanced by several smaller figures or objects on the other side?

Another possible kind of balance is radial balance (or symmetry). The garden at the Taj Mahal is planned in such a way that each design element is repeated equidistant from a central point, giving a sense of harmony and perfection (**27**).

27 The Taj Mahal, designed by Ustad Ahmad Lahauri, Abd al-Karim Ma'mur Khan, and Makramat Khan; commissioned by Shah Jahan, 1632–43. Marble architecture. Agra, India

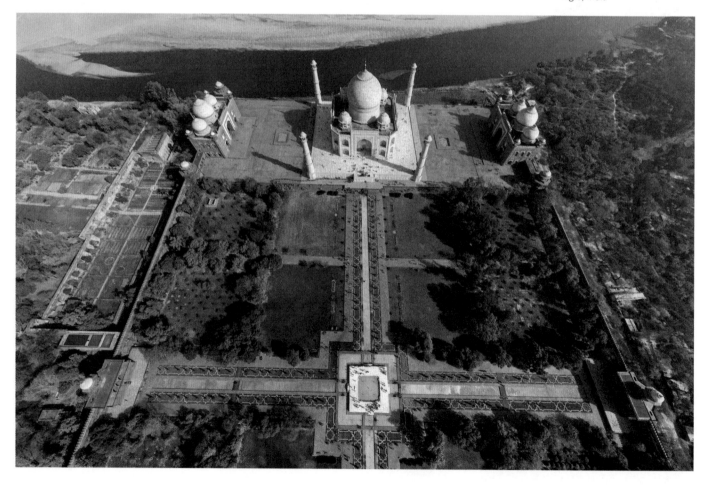

Scale and Proportion

Consider the **scale** of the actual artwork and how it relates to the size of the person viewing it.

Now, in addition to considering the overall scale of the work, consider the relative size (the **proportion**) of its parts (**28**). For example, if the figure is human, is the head unusually large, or are the arms abnormally long? Or is an object that is small in reality presented as larger than usual in the artwork (**29**)?

Are any figures or objects within the work larger than others (**hierarchical scale**), and if so, why?

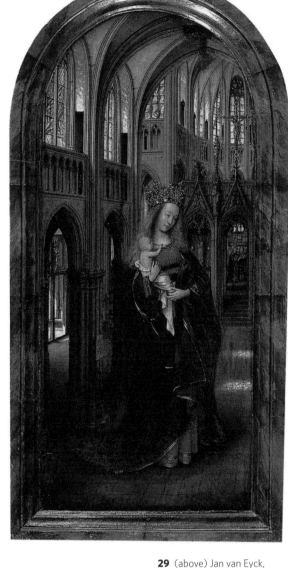

28 (below) Examples of how proportion changes on vertical and horizontal axes:
- **A** the original form;
- **B** when the width is reduced, the vase seems elegant and light;
- **C** reducing the height makes the vase seem clumsier and weightier

29 (above) Jan van Eyck, *Madonna in a Church,* 1437–38. Oil on wood panel, 12⅝ × 5½". Gemäldegalerie, Staatliche Museen, Berlin, Germany

The Golden Section and the Golden Rectangles

The **Golden Section** (also referred to as the Golden Mean or Golden Ratio), is a proportional ratio of 1:1.618, which occurs in many natural objects and gives naturalistic results when applied to statues.

Artists have learned to apply proportional formulas to organize their compositions and ensure that their work is visually interesting. One such technique is known as "Golden Rectangles", which involves nesting a succession of rectangles (all based on the 1:1.618 proportions of the Golden Section) inside one another (**30**). The shorter side of the outer rectangle becomes the longer side of the smaller rectangle inside it, and so on. The result is an elegant spiral shape.

See *Gateways to Art*, 3e, pp. 147–48 for more on this topic.

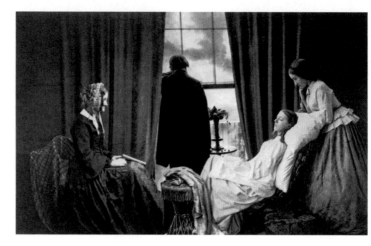

31 Henry Peach Robinson, *Fading Away*, 1858. Combination albumen print, 9½ × 15½". George Eastman House, Rochester, New York

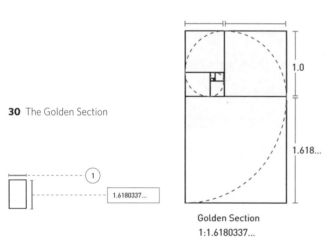

30 The Golden Section

Golden Section
1:1.6180337…

1.6180337…

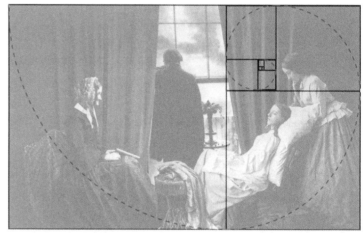

32 Proportional analysis of the photograph

Pattern

Can you identify any repetition of an element (such as shape, value, or color) in the artwork that creates a **pattern**?

A design or color repeated as a unit in a pattern is called a motif. A **motif** in an artwork might be the repetition of a flower, leaves, or animals, but it could also be the repetition of a geometrical design.

Rhythm

Rhythm is the ordered or regular repetition of elements in a work. Can you identify any elements in the artwork that create rhythm?

Identify the type of rhythm used: is it simple repetitive rhythm, progressive rhythm, or alternating rhythm (see *Gateways to Art*, 3e, pp. 163–68)?

Focal Point, Emphasis, and Subordination

Has the artist used any elements of the artwork to draw attention to particular parts or aspects of the work ("**emphasis**")? How does the artist direct the viewer's eye to the **focal point**? For example, does the artist use line, contrast, placement, or some other method?

Or, on the other hand, has the artist drawn attention away from particular parts or aspects of the work ("**subordination**")?

Pieter Bruegel's (1525–1569) painting *Landscape with the Fall of Icarus* (**33**) illustrates a story from Greek mythology. Daedalus and his son Icarus are imprisoned on the island of Crete by the ruler, Minos. They try to escape using homemade wings, but Icarus flies too close to the sun and the wax attaching his wings melts, causing him to fall and drown.

When we look at the artwork, our attention is drawn first to the figure in the red smock, who plows his field, unaware of the tragedy. Next we might notice the tree on the left or the large ship on the right. It is easy to miss poor Icarus drowning in front of the large ship, his feet hardly distinguishable from the whitecaps and the tiny seabirds circling near the vessel.

Bruegel has gone to such lengths to draw attention away from the plight of his subject that art historians think he is illustrating the Flemish proverb, "No plough stands still because a man dies." Or, as we might say, "Life goes on." Either way, it is a brilliant example of using emphasis and subordination to direct and control the way in which the viewer perceives the painting.

33 Pieter Bruegel the Elder, *Landscape with the Fall of Icarus*, c. 1555–58. Oil on canvas, mounted on wood, 29 × 44⅛". Musées Royaux des Beaux-Arts de Belgique, Brussels, Belgium

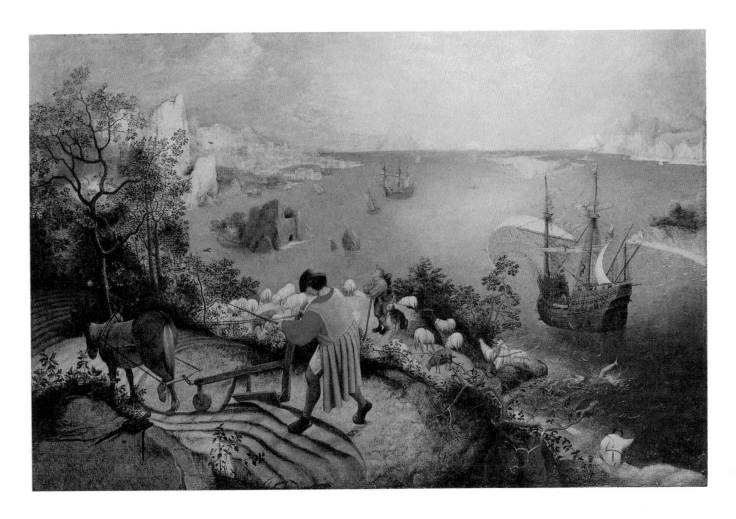

ASSIGNMENT #1: VISUAL ANALYSIS OF AN ARTWORK

Select one work of art and perform a formal analysis on that work. To do so, consider each of the elements and principles discussed in this guide. Write your observations below. If you are writing an essay, your conclusion should discuss how the elements and principles were used by the artist to create the focal point or emphasis of the work.

• Line	
• Shape	
• Form	
• Volume and Mass	
• Texture	
• Value	
• Space and Implied Depth	
• Color	
• Motion and Time	
• Unity	
• Variety	
• Balance	
• Scale and Proportion	
• Pattern	
• Rhythm	
• Focal Point, Emphasis, and Subordination	

ASSIGNMENT #2: CREATE A COMPOSITIONAL DIAGRAM

Create a compositional diagram of a work of art. This diagram should highlight how the dominant elements and principles function. Alternately, consider how the artist used the elements and principles to make the point/s of emphasis. **Figure 34** demonstrates a compositional diagram applied to Velázquez's famous painting *Las Meninas*, which is also reproduced on the cover of this Journal.

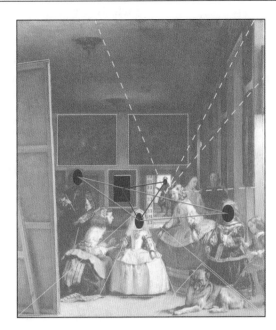

34 Compositional diagram of *Las Meninas*

Media

Now that you have completed your visual analysis of the artwork, it is a good time to think about the artist's materials and the methods used to create the work. The media an artist chooses can be two- or three-dimensional. Think about why the artist chose a particular medium (method) and whether the specific media (materials) chosen imposed any limits on the artist?

Two-dimensional media

Drawing

Consider the materials utilized: pencil, silverpoint, chalk, charcoal, crayon, pastel, ink, wash. Was the artist able to make controlled strokes with this medium? Would the tool used create a thick or thin line? One that was defined, or blurred? Was the drawing intended to be a work of art in itself? Or is it a study for another work, a peek into the artist's creative process? Does the medium itself emphasize expressiveness, as in Kollwitz's *Self-Portrait in Profile* (**35**)?

Painting

How did the type of paint affect the brushstrokes the artist could make? Was the artwork created in fresco, oil, tempera, watercolor, encaustic, acrylic, or some other type of paint? Was it a fast-drying paint that gave the artist little time to make changes? What kind of textures and lines was the artist able to create with this medium? Does it create a shiny or a flat look? How durable was the medium? How was the paint applied to the surface: with a brush, a palette knife, dripped, or sprayed?

Printmaking

What is the process the artist undertook to create this work? Was it relief (a surface was carved to create a raised image; **36**), intaglio (the artist cut into a surface to create the image; **37**), or planographic (the print was made from an entirely flat surface; **38**)? Did the artist need to engrave or etch? Did the artist use lithography or silkscreen printing? Strength or patience?

36 (below) A brief overview of the relief printing process:
1 An image is designed and is prepared for transfer to the block surface.
2 The image is now transferred to the block.
3 The surface area that will not be printed is carved away.
4 The remaining protruding surface is carefully inked.
5 The raised inked area is transferred to the surface to be printed.

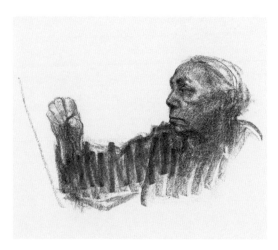

35 (above) Käthe Kollwitz, *Self-Portrait in Profile to Left*, 1933. Charcoal on paper, 18¾ × 25". National Gallery of Art, Washington, D.C.

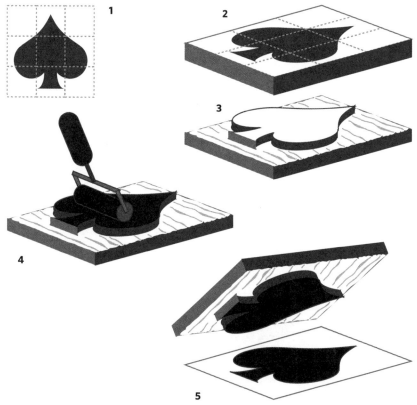

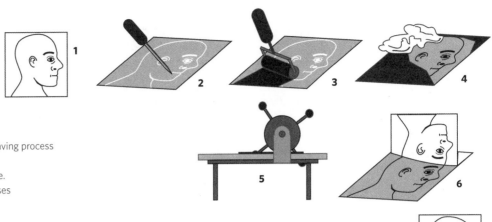

37 (right) A brief overview of the engraving process (intaglio)

 1 An image is designed for the plate.

 2 Using a sharp tool, the artist incises the image into the plate.

 3 The plate is inked.

 4 The surface of the plate is wiped, removing all ink except in the grooves.

 5 Paper is placed on the plate and it is pressed.

 6 The paper lifts the ink out of the grooves and the ink is imprinted on the paper.

 7 The final image is complete. (In most printmaking methods the final image is reversed from the plate or block.)

38 (below right) A brief overview of the lithography process:

 1 The artist designs the image to be printed.

 2 Using a grease pencil, the design is drawn onto the limestone, blocking the pores.

 3 The stone is treated with acid and other chemicals that are brushed onto its surface. Then the surface is wiped clean with a solvent, such as kerosene.

 4 The stone is sponged so that water can be absorbed into the pores of the stone.

 5 Oil-based ink is repelled by the water and sits only on areas where the oil crayon image was drawn.

 6 Paper is laid on the surface of the stone and it is drawn through a press.

 7 The print is removed from the stone.

 8 The completed image appears in reverse compared with the original design.

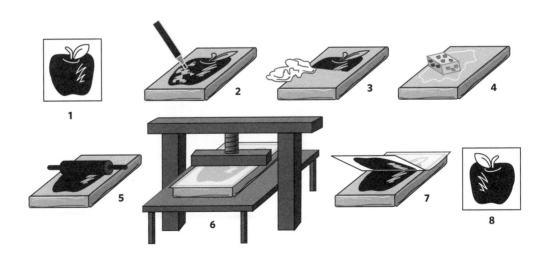

Visual Communication Design (also Known as Graphic Design)

What format has the designer chosen (poster, book, advertisement, etc.)? Is the work color or black and white? How does the artwork combine text and images? What kinds of typefaces has the artist selected? What information or ideas do you think the designer intended to communicate (**39**)?

Photography

Was the photograph made using film or a digital camera? Is it in color or black and white? Does it appear to have been manipulated in any way? What is the subject matter: is this a portrait, a still life, a photograph that documents a real event, or does it in some way express an artistic idea?

Photocollage/Collage

Has the work of art been assembled by gluing materials—often paper, but also photographs, for example—onto a surface? What do you think the artist intended by making a **collage**?

Film or Video

Is the film or video in color or black and white? Is it silent or is there sound? Is it shown on a small screen or projected on to a large one? Is it shown in an enclosed space or in a gallery alongside other works?

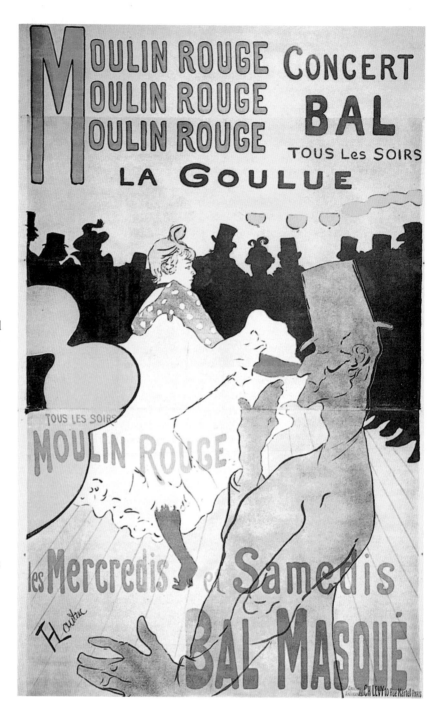

39 Henri de Toulouse-Lautrec, *La Goulue at the Moulin Rouge*, 1891. Lithograph in black, yellow, red, and blue on three sheets of tan wove paper, 6'2½" × 3'9⅝". Art Institute of Chicago, Illinois

ASSIGNMENT #3: SPACE AND DEPTH IN A TWO-DIMENSIONAL WORK

Many two-dimensional works of art try to create the illusion of a three-dimensional space. Select a work of art that successfully shows a sense of depth. On this page, sketch out how the artist utilized the following "tricks" of illusionism:

1. Use of size differentiation, i.e. one type of object (tree, person, building) that is shown at different distances.
2. Use of linear perspective that identifies the **vanishing point** (see **18**, p. 13).
3. Use of atmospheric (aerial) perspective (see **16**, p. 12).

Three-dimensional Media

Sculpture

Is the sculpture in high or low relief (**40**), or can we see the object in the round? What challenges did the material present to the artist? Was the object created through a subtractive process (beginning with a large mass of the medium and taking away from it to create form; **41**) or an additive process (in which sculptors add material to make the final artwork; **42** and **43**)? What tools did the artist use to create the form? If the form is human, is the artwork lifesize? Was the sculpture made by appropriating or adapting an everyday object (a found object)?

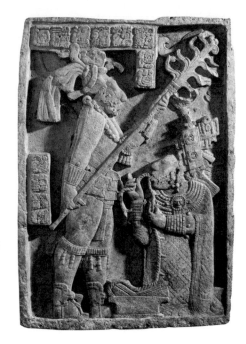

40 Maya lintel showing Shield Jaguar and Lady Xoc, c. 725 CE. Limestone, 43 × 30¾ × 2⅜". British Museum, London, England

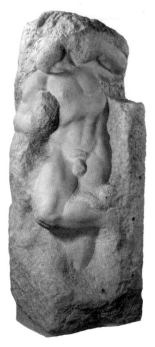

41 Michelangelo, *Prisoner*, known as the *Awakening Slave*, 1519–20. Marble, height 8'9⅛". Galleria dell'Accademia, Florence, Italy

42 (right) *Riace Warrior A*, c. 460 BCE. Bronze with copper, silver and ivory, height 6'6". Museo Nazionale della Magna Grecia, Reggio di Calabria, Italy

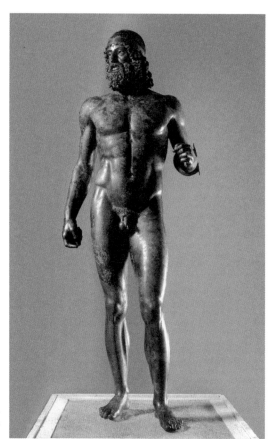

43 (below) Seven steps in the lost-wax casting process

Architecture

Does the building represent the work of a community or the power of a leader? How was it constructed (**44** and **45**)? What was the structure's intended use? How does it fit with its surroundings? Is it a domineering or welcoming structure? What is the viewer's experience when interacting with the space? Are there references to **Classical** art (**46**)?

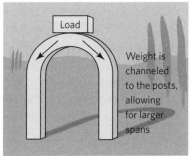

44 Post-and-lintel construction

45 Arch construction

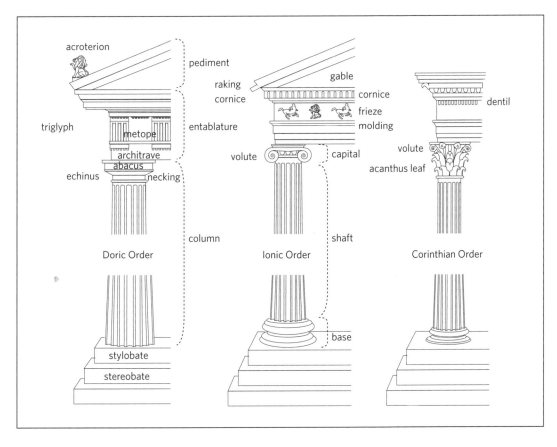

46 Diagram of the Classical architectural orders, differentiating between the Doric, Ionic, and Corinthian. Key parts of Greek temple design, such as the pediment, entablature, frieze, capital, column, shaft, and base are also identified

47 Tunic, *c.* 1500. Interlocked tapestry of cotton and wool, 35⅞ × 30⅛". Dumbarton Oaks Research Library and Collections, Washington, D.C.

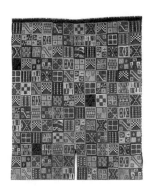

Happenings and Performance Art

Is the work one that we witness or enter to experience? Is it impromptu or ephemeral? Is the medium the human body? Are any objects destroyed or altered?

Traditional Craft Media

Is the work made of ceramics, glass, metal, fiber (**47**), wood, or some other material (perhaps a modern synthetic material, or an everyday object)? Why do you think the artist chose a particular material: is it strong and durable, is it flexible, does it have a particular texture?

ASSIGNMENT #4: ANALYSIS OF A THREE-DIMENSIONAL ARTWORK

Examine a three-dimensional work of art from at least five different viewpoints. Walk around the work, look at it from below and from above (if possible). Take pictures or sketch what you see from each point of view. Based on your observations, answer the following questions:

1. Why do you think the artist chose to make the work of art a relief as opposed to in the round (or vice versa)?

2. Do you think the artist expected the viewer to see the work from all angles, or would he/she have preferred the viewer to stand in one location?

3. Does anything about the work make you think the artist considered what kind of lighting would surround the work?

4. Do you have a favorite viewpoint? Why?

ASSIGNMENT #5:
MATERIAL ANALYSIS

Select two three-dimensional works that are made from different materials. Answer the following questions about each work:

1. What material was used to make this work?	
2. Is the material malleable or hard?	
3. If the artist made a mistake, do you think it was easy to correct this mistake with this material?	
4. Was the process additive or subtractive?	
5. Why do you think the artist chose this material for this work?	
6. If each of the works you chose were made with the medium of the other work, how would they be different?	

Modes of Analysis

Artworks communicate visual ideas. As well as considering the visual language of a work (what is known as "visual analysis") and the media used to create it, we must also consider what the artist wanted to communicate: the work's content. Several modes of analysis are employed by art historians to interpret a work, and these can often be combined. Based on what you can tell from looking at the work, by studying the gallery or museum label, and by applying any background knowledge or research, you can take your analysis of your chosen work further.

Ask yourself whether you can apply any of the following methods to your chosen artwork:

Formal Analysis

Formal analysis involves looking closely and in detail at the work in order to consider how the formal elements and principles of art are used to create it and to convey meaning.

Stylistic Analysis

Stylistic analysis focuses on the characteristics that make a work of art distinctive to identify how they typify the work of an individual, are shared by a group of artists to create a movement, or are concentrated in a particular place or time period.

Iconographic Analysis

Iconographic analysis interprets objects and figures in the artwork as signs or symbols, often based on religious or historical contexts that would have been fully understood at the time it was made.

Contextual Analysis

Contextual analysis looks at the making and viewing of the work in its context (historical, religious, political, economic, and social); it studies the context that the artwork itself represents.

Biographical Analysis

Biographical analysis considers whether the artist's personal experiences and opinions may have affected the making or meaning of the artwork in some way.

Feminist Analysis

Feminist analysis considers the role of women in an artwork as its subjects, creators, patrons, and viewers; it explores ways in which the work reflects the experience of women.

Gender Studies Analysis

Gender Studies analysis expands the considerations raised by feminist analysis to explore ways in which the work reflects experience based on a person's gender.

Critical Race Theory Analysis

Critical race theory analysis is a method of interpretation that critically examines society and culture as it intersects with race, power, and institutional practices.

Psychological Analysis

Psychological analysis investigates an artwork through interpretation of the mental state of the artist when he or she created the work.

48 Frida Kahlo, *The Two Fridas*, 1939. Oil on canvas, 5'8" × 5'8". Museo de Arte Moderno, Mexico City, Mexico

Several modes of analysis can be used to understand this painting.

- Biographical Analysis: This painting was made while the artist was experiencing a difficult divorce.
- Feminist Analysis: As a woman painter who defied gender stereotypes, Kahlo is often viewed through a feminist lens.
- Iconographic Analysis: Kahlo's clothing symbolizes her ancestry, while the brooch she holds, and her split and bleeding organ, symbolize her broken heart.
- Psychological Analysis: Frida painted more than fifty self-portraits that express her physical and emotional struggles.

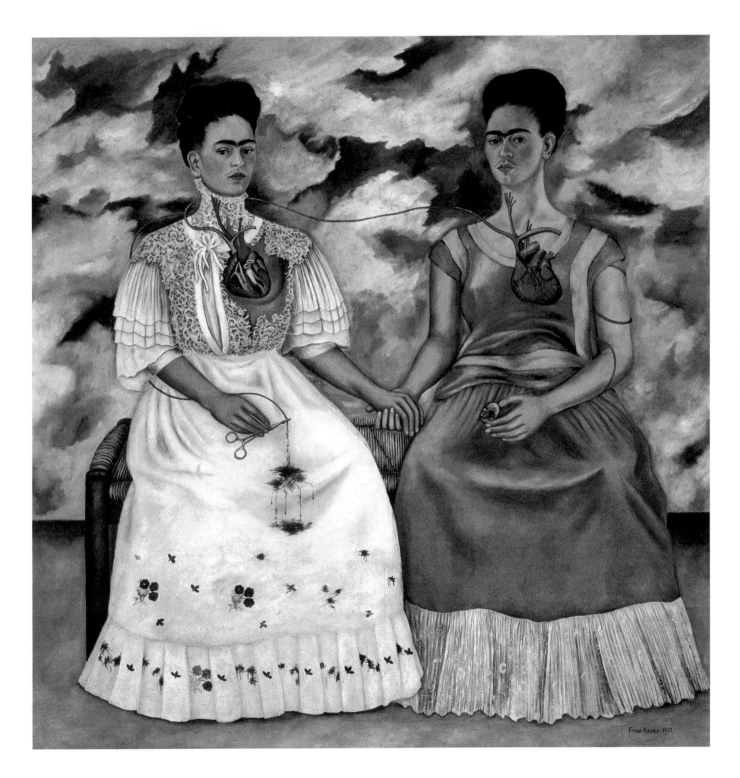

History and Culture

To varying extents, all works of art reflect the time and place in which they were made.

Edgar Degas was influenced by the fact that he lived in Paris, France in the late nineteenth century. His seemingly quick strokes of pastel (**49**) are similar to other **Impressionist** sketches and paintings of the time. The **cropping** of the image and the angle from which he observes the dancers also show the influence of photography (at the time a fairly recent development) on the artist (**50**).

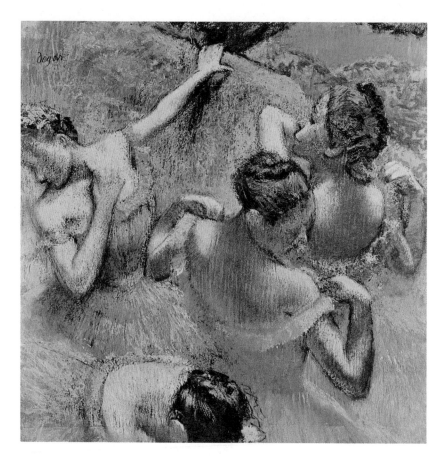

49 Edgar Degas, *Blue Dancers*, c. 1898. Pastel on paper, 25½ × 25½". The Pushkin State Museum of Fine Arts, Moscow, Russia

50 Edgar Degas, *Dancer Adjusting Her Two Shoulder Straps*. Modern print from gelatin dry-plate negative. Bibliothèque nationale de France, Paris, France

ASSIGNMENT #6: HISTORY AND CULTURE ANALYSIS

The arrangement of works in the rooms of the museum, together with the information provided on the work's label, will usually help you learn something about the historical context of the artwork. Explore the context of your work of art by answering the following questions:

1. Identify the date and culture of your work.	
2. What do you know about what was taking place in that time period in history? Do the artwork or its label give you any clues?	
3. Is your work placed near other objects from the same era?	
4. Are works organized by culture (American, Chinese, etc.)?	
5. Is your work exhibited with works by other artists that are similar in **style** (for example, **Abstract Expressionist**, Impressionist, **Cubist**)?	
6. How do you see that context may have influenced this artist when creating his or her work of art?	

Theme

Artworks reveal the concerns of humanity. Throughout the world, similar issues, or themes, are explored by artists. By comparing artworks in terms of their meaning, we can come closer to understanding the uniqueness of different cultures and artists.

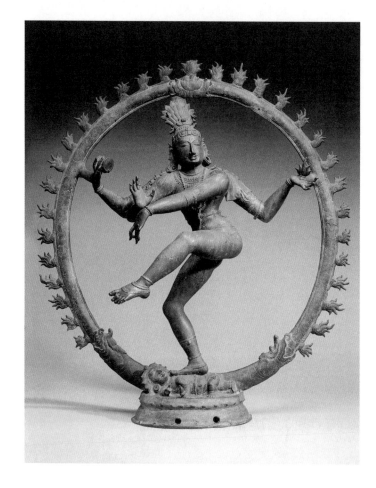

51 *Shiva Nataraja* (*Lord of the Dance*), Chola Period, India, 11th century. Bronze, height 43⅞". Cleveland Museum of Art, Ohio

ASSIGNMENT #7, QUESTION 1: ANALYSIS OF THEME

When considering the meaning or message of a work of art, ask yourself the following:

	YES	NO
1. Does the work relate to a community issue?		
2. Does the work embody religious or spiritual beliefs (**51**)?		
3. Does the work reference the cycle of life (birth, family, age, death, the afterlife, nature)		
4. Does the artwork relate to science or technology?		
5. Does the artist use illusionism in the work?		
6. Are rulers or leaders depicted or referenced in the work of art?		
7. Are episodes of war or times of conflict represented?		
8. Does the artist address concerns for a societal issue?		
9. Is the body depicted?		
10. Is someone's identity addressed (such as gender or race)?		

ASSIGNMENT #7, QUESTION 2:
ANALYSIS OF THEME
CONTINUED

After selecting a theme (topic, issue, or category) that you believe is present in your selected work of art, delve into the theme by answering the following:

1. Identify and clarify a theme of the painting in one to two sentences.

2. Find another artwork with the same theme and compare them. What is similar about how the two artists treated the theme? What is different?

3. Do you think the artist thought about other works with the same theme when creating his or her own? Why, or why not?

Understanding What Museums Do

Visiting a museum is a great way to boost your knowledge of art history. You can learn about your local heritage and that of other cultures. In this section, we take a look behind the scenes at a selection of museums across the United States. Learning about these museums will assist you in discovering the services that may be available in your own museum and shed new light on the varied functions that museums fulfill in your community.

Museums Shape Our Experience of Art

The Museum of Modern Art, NY

Art history does not just happen: our view of how art has developed over time has been shaped by scholars, critics, and by museums and their **curators**. Some museums have played an especially important role in this regard: the Museum of Modern Art (MoMA) in New York is one of the most influential museums in the world.

Since its foundation in 1929, MoMA has shaped the history of modern art in several ways. Its curators choose which artworks from the collection to display, and how these should be presented. The information labels on the wall and the position and order of the artworks in each gallery represent a narrative told to the visitors by the curators.

As well as selecting objects for the museum's permanent collection, curators organize temporary exhibits (shown in a museum for a limited time, usually several months) and retrospectives, shows that take a look back at the work of a particular artist over a certain period of time.

In 1939–40, MoMA held a retrospective of the work of Pablo Picasso (1881–1973), when the artist was nearly sixty (**52**). By representing a wide range of his artworks across a variety of

media and including some artworks that were on show for the first time, the museum reinterpreted Picasso's art and played an important part in establishing his reputation as the greatest artist of his time. In this way, the exhibit had an impact on the remainder of Picasso's career, as it meant that the public became more informed and enthusiastic about his work.

■ Even if it is not possible for you to visit MoMA, you can still experience some of the most important works in this world-class museum by accessing the video resources that accompany *Gateways to Art*. In these videos, MoMA curators share fascinating insights about the most famous masterpieces from the collection, which features artworks by Pablo Picasso (1881–1973), Henri Matisse (1869–1954), Vincent van Gogh (1853–1890), and many others.

52 Pablo Picasso, *Les Demoiselles d'Avignon*, 1907. Oil on canvas. 8' × 7'8". MoMA, New York

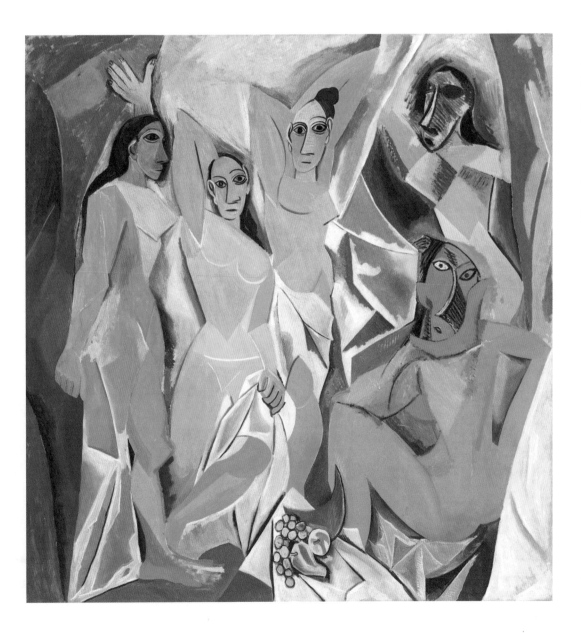

Kimbell Art Museum, Fort Worth, TX

The architecture of a museum is designed to convey a sense of the importance of the institution's role in caring for invaluable works of art. The Kimbell Art Museum commissioned the architect Louis I. Kahn (1901–1974) to create their world-renowned museum space, which today is used to display their permanent collection. In 2013, Renzo Piano (b. 1937) designed a complementary colonnaded pavilion used for special exhibitions.

In traditional American museums, works of art are given ample space so that each work of art can be studied without distraction. Lighting is considered not only so that the art objects can be easily viewed, but also so they can be protected as light is damaging to many artworks (**53**). The Kimbell Art Museum holds works from Africa, Asia, and the Ancient Americas, and is known for selecting superb representative examples of individual European artists. The Kimbell is also known as an attraction for some of the most well-attended traveling exhibitions.

53 Kimbell Museum of Art, Fort Worth, Texas

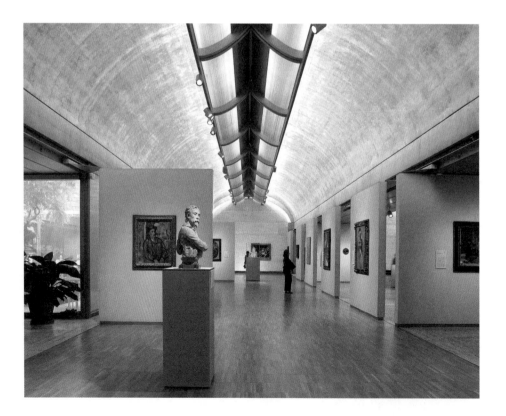

ASSIGNMENT #8:
MUSEUMS SHAPE OUR
EXPERIENCE OF ART

Consider the permanent collection in your local museum, and also the design of the museum itself. Answer the following questions:

1. What kind of art do you think the curators consider to be most important, and why? How have they organized the collection? Think about which artworks are displayed together and whether any are given special prominence.

2. What style is the museum built in (e.g. Classical, Modernist, Postmodern)? Does the style of the building relate to the type of art on display inside? How do the light and space in your museum affect your perception of the works of art?

3. How do visitors enter the museum—through multiple entry points or one main entrance? What is the layout of the museum—are visitors encouraged to wander and view the objects in any order, or do they follow a set route from exhibit to exhibit?

Museums Preserve Our Heritage

The Museum of Fine Arts, Houston, TX

Every museum collection represents a portion of humanity's artistic **heritage**, the objects and traditions that we value. The artworks in local museums can also teach us a lot about our regional heritage.

The Museum of Fine Arts, Houston, has a fine selection of art from many eras and cultures. It provides an insight into the heritage of Western art, with works by such European masters as Rogier van der Weyden (*c.* 1400–1464), Rembrandt van Rijn (1606–1669), Francisco Goya (1746–1828), and Claude Monet (1840–1926).

On a national level, the museum's Bayou Bend annex has an excellent collection of American **decorative arts**, works of art designed for both utility and visual appeal, including furniture, textiles, and metalwork, with each room specially designed to match the objects displayed in it.

Finally, a noteworthy collection of Frederic Remington's (1861–1909) paintings of cowboys on the Western frontier brings the city of Houston's nineteenth-century frontier past to life for its modern inhabitants, giving them a sense of their local heritage (**54**).

54 Frederic Remington, *Aiding a Comrade*, 1889-90. Oil on canvas, 34⅜ × 48⅛". Museum of Fine Arts, Houston, Texas

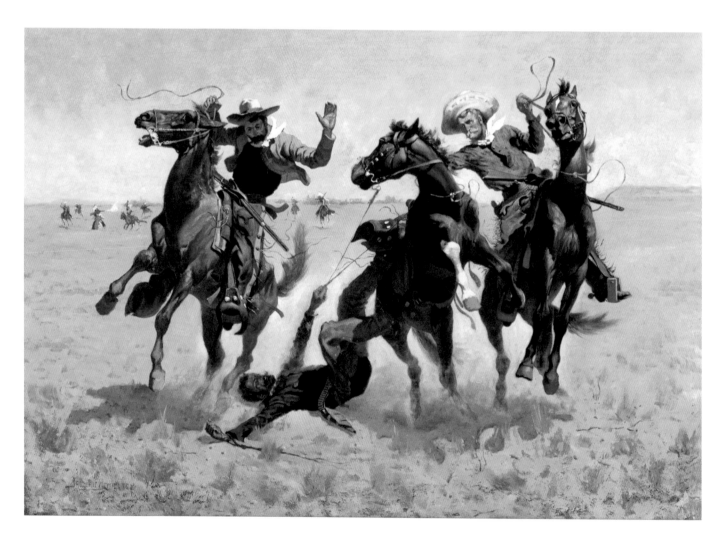

Toledo Museum of Art, OH

While the Toledo Museum of Art holds a diverse and impressive collection of art, the museum is renowned for its collection of glassworks. As the birthplace of many inventions in the glass industry, glassmaking is an important part of Toledo's history. In 1969, the Toledo Museum of Art became the first museum to build a facility specifically designed for teaching and practicing glass-working techniques.

The Glass Pavilion, designed in 2006 by Japanese architects Kazuyo Sejima (b. 1956) and Ryue Nishizawa (b. 1966), is made of both interior and exterior walls of (often curved) glass. The building was created specifically to house the glass collection and continue the tradition of offering studio space for glass artists and classes for visitors (**55**).

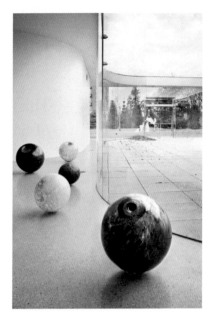

55 Glass Pavilion, Toledo Museum of Art, Ohio, showing Dale Chihuly's *Niijima Floats*, 1992

ASSIGNMENT #9: MUSEUMS PRESERVE OUR HERITAGE

1. Is your region known for any folk or decorative art traditions, or any famous artists who were born or worked there?	
2. Does your museum feature artworks that highlight your local or personal heritage? If so, which ones, and what is their connection to your region or country?	

Museums Teach the History of Art

The J. Paul Getty Museum of Los Angeles, CA

Many museums also have an education department where **art educators** develop a wide range of programs and resources for a variety of audiences. The J. Paul Getty Museum (**56**) is home to one of the pre-eminent education departments. As well as organizing activities and events for schoolchildren and adult learners, it hosts regular College Nights, with gallery tours led by a curator or **conservator** (a member of museum staff who is responsible for repairing the objects in the collection and preserving them for future visitors). The Getty also holds a substantial library of resources that scholars from around the world are invited to utilize.

The Getty's outreach program also extends beyond the museum walls, as it has made thousands of high-resolution images of its collection available online; these are free to use, modify, and publish for any purpose and can be found at getty.edu/art. The Getty's YouTube video stream also hosts videos filmed at archaeological sites, artist's studio visits, and analyses of individual artworks. Many important archival documents have also been put online to be accessed by the general public.

56 Richard Meier, The J. Paul Getty Museum of Los Angeles, California, 1997

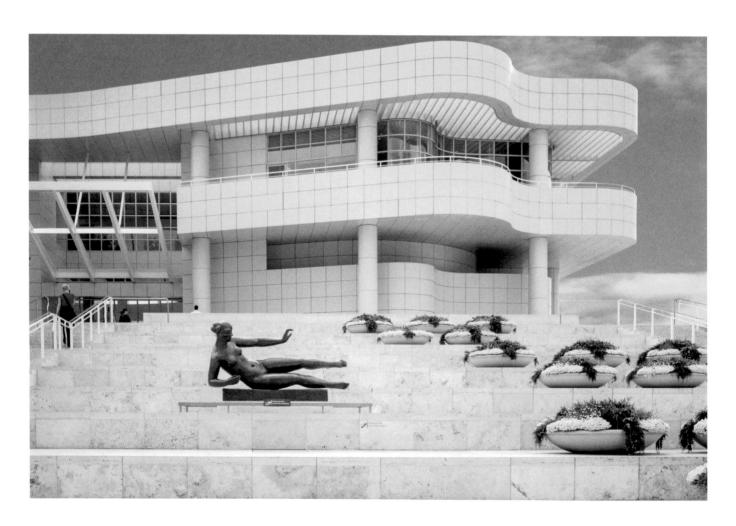

Portland Art Museum, OR

We often hear about museums acquiring a particularly important artwork, but it is rare for a museum to be able to add to its holdings an entire collection of art that documents the important artists of an era. In 2000, the Portland Art Museum (**57**) was fortunate enough to acquire the collection of the influential art critic Clement Greenberg (1909–1994).

Greenberg was a critic who championed **avant-garde** American art styles, such as Abstract Expressionism, and helped many artists to achieve international recognition. He was also an important influence in artists' studios, offering them advice on developing, cropping, and hanging their work.

Over a period of 50 years Greenberg collected 159 paintings, prints, drawings, and sculptures by some of the most prominent artists of the twentieth century, including, for example, 43 works by Kenneth Noland (1924–2010) from 1958 to 1981. The career of Jules Olitski (1922–2007) is documented by 23 works from 1965 to 1982. This collection provides viewers with the unique opportunity to study the development of these artists, to gain insights into the preoccupations of artists in Greenberg's time, and to evaluate each artist's work alongside that of his or her peers.

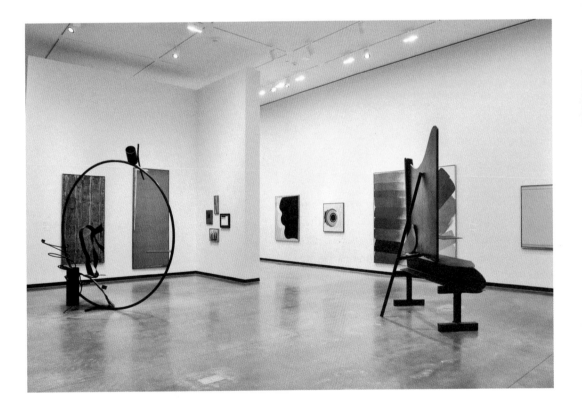

57 Works from the collection of Clement Greenberg on display at the Portland Museum of Art, Oregon

ASSIGNMENT #10:
MUSEUMS TEACH
THE HISTORY OF ART

1. Is there an education department at your museum? What sorts of programs does it run, and what kinds of audiences does it aim to reach?

2. Does your museum also have an online collection of its art? What other resources does your museum offer on its website? Can you think of other ways in which a museum could offer the public an enhanced experience of its collections?

3. Does your museum include works that once belonged to an influential critic, a wealthy local citizen, or somebody else who succeeded in forming a significant collection of artworks? What can the collection tell you about the art of its era?

Museums Reach out to the Public

The Birmingham Museum of Art, AL

There are many professionals in your museum who help visitors enjoy and understand the art on display. While curators are in charge of organizing exhibitions and providing information about the artworks, **docents** are trained to act as guides to the artworks on display. They are generally very knowledgeable about the collection, and can often help you identify what to look for when viewing an artwork, or explain why an artist might have chosen a particular medium or style.

The docents at the Birmingham Museum of Art in Alabama host a number of activities for all ages, from free family tours to the museum's Visually Impaired Program, in which those with vision difficulties can handle works of art, with the help of specially trained guides (**58**). Docents may also schedule lectures from art history professors and artists, as well as evening events and festivals, where visitors can view the art alongside concerts and performances.

58 Visitors examining a bronze sculpture as part of the Visually Impaired Program at the Birmingham Museum of Art, Alabama

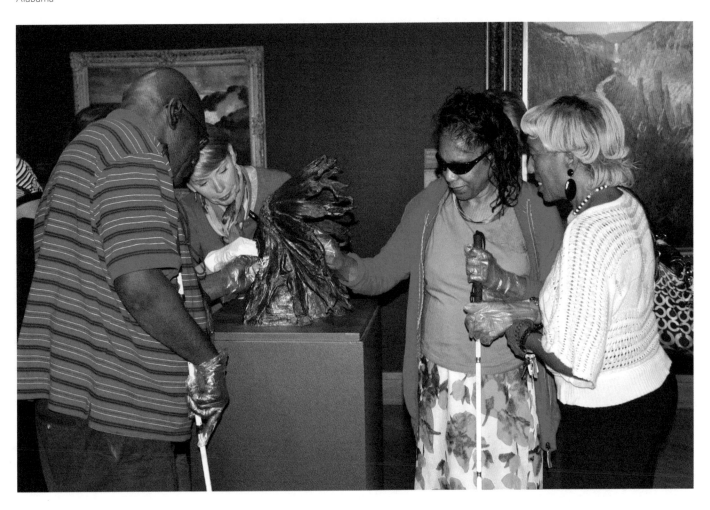

The Tucson Museum of Art, AZ

The collection at the Tucson Museum of Art is similar to that at the Houston museum, not only including some Western art but also featuring art that reflects Arizona's rich local heritage. One part of the collection explores links to Native American culture (twenty-two tribes live in the state today), including works that show combined Native American and Euro-American influences, demonstrating the impact of cultural exchange over time.

The museum's collection of Pre-Colombian art of the Americas presents a wide range of the ancient artistic traditions of the continent, as well as art of the Portuguese and Spanish colonies in the Americas (Arizona was, of course, once a Spanish colony and was part of independent Mexico until 1848). The Tucson Museum of Art also includes five historic properties, collectively called Historic Block, which are open to the public. The mid-nineteenth-century La Casa Cardova is an adobe Sonoran row house and holds a diorama of the birth and death of Christ (*El Nacimiento*) (**59**).

59 La Casa Cordova at the Tucson Museum of Art, Arizona

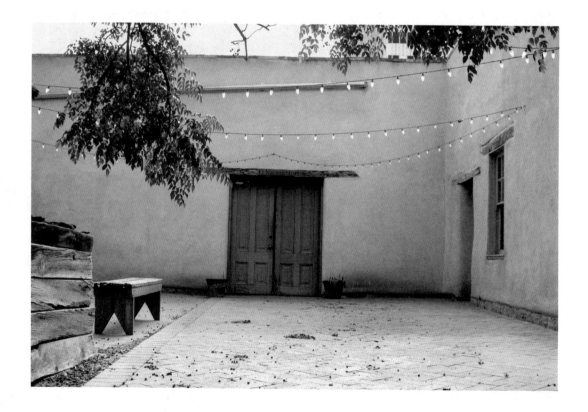

ASSIGNMENT #11:
MUSEUMS REACH
OUT TO THE PUBLIC

1. Think about the artworks on display at your museum. What cultures do they represent?

2. Does your museum offer any special tours, lectures, or events hosted by docents? Does the museum host any other sorts of event? Are these events free of charge? Does the museum have any free or reduced-fee days or hours?

3. What sorts of media (such as movie screenings) and facilities (such as restaurants) are in place to attract visitors to the museum? How is the local or regional community involved in museum events?

Museums Respond to Local Needs

High Museum of Art, Atlanta, GA

Museums evolve by updating and expanding their collections in response to the latest views on art. High Museum has altered over time by innovatively responding to societal changes.

The museum started life in the High family home in 1905 before moving to a purpose-built space in 1983. It holds one of the strongest collections of photography in the United States due to the museum's foresight in collecting the medium heavily from the 1970s onward. In 1996, the High was the first museum in the world to establish a dedicated department for **folk** and **self-taught** art, including works by such Southern artists as Bill Traylor and Sam Doyle, as well as the Mexican-born Martín Ramírez (**60**) and Joseph Yoakum, who is of mixed African-American and Native American descent. Although museums take strict measures to protect objects from the past, they are not always rigid about keeping knowledge about traditional uses for those objects alive. In this case, the High Museum has been known to re-evaluate the significance of artworks that were previously not thought to be important enough to be exhibited.

The High Museum was also one of the first museums in the United States to collaborate with the Louvre in Paris, France, which holds one of the largest collections of art in the world. This partnership allowed visitors to the High Museum to experience hundreds of artworks from the Louvre collection in 2006 and 2009 without having to travel to Europe.

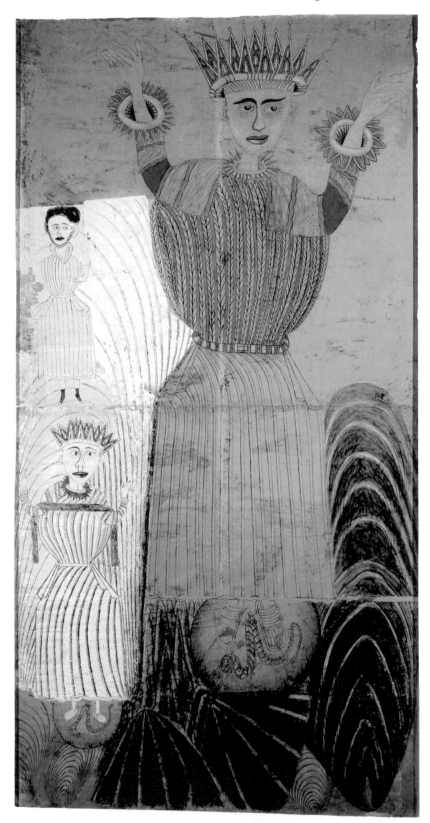

60 Martín Ramírez, *Untitled (La Inmaculada)*, 1950s. Crayon, pencil, watercolor, and collaged papers, 92 × 45". High Museum of Art, Atlanta, Georgia

A Global Museum for a Global World

The Pérez Art Museum, Miami, FL

Most major cities in the United States have an important art museum, but until 1996, Miami did not. In 2013, the museum acquired 500 important contemporary works when the museum moved and changed its name to acknowledge the donor Jorge M. Perez, who has shared much of his spectacular Latin American art collection.

Miami's population includes many recently arrived immigrants, especially from the Caribbean and Latin America, and the city is home to a vibrant artistic community. The Pérez Art Museum reflects the contemporary and international character of the city. Its collection features works by such artists as American Kehinde Wiley (b. 1977), Cuban Bedia Valdés (b. 1959), and Colombian Beatriz González (b. 1938).

The Pérez Art Museum (**61**) is a vital part of the wider contemporary art scene in Miami. Every December, the museum hosts a special exhibition to welcome visitors to the annual Art Basel Miami Beach, a modern and contemporary art fair that attracts artists, dealers, collectors, curators, critics, and art enthusiasts. The museum and the art fair have helped to make Miami a major center for contemporary global art.

61 Herzog & de Meuron Ltd, The Pérez Art Museum, Miami, Florida, 2013

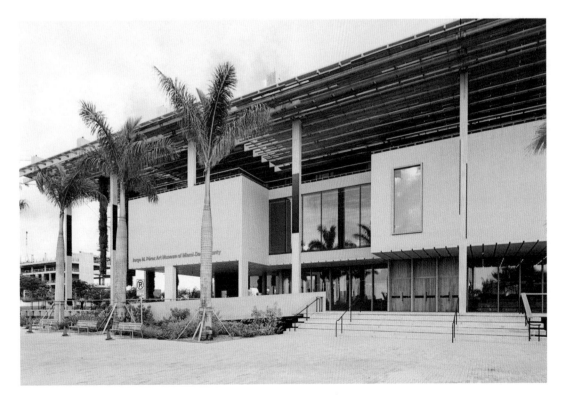

ASSIGNMENT #12: A GLOBAL MUSEUM FOR A GLOBAL WORLD

1. Do some research online about your museum's origins, and describe how both the building and its collection have changed over the years. If your museum has only recently opened, do some research and find out if it has any particular aims or areas in which it intends to specialize.

2. How has the permanent collection at your museum evolved over time? Did it begin life as the private property of a prominent collector or family? If so, what kind of art did the family or individual originally collect?

Glossary

Abstract (1) art imagery that departs from recognizable images of the natural world; (2) an artwork the form of which is simplified, distorted, or exaggerated in appearance

Abstract Expressionism a mid-twentieth-century artistic style characterized by its capacity to convey intense emotions using non-representational images

Actual line a continuous, uninterrupted line

Analogous colors colors adjacent to each other on the color wheel

Art educators people that work in the education department of a museum or gallery

Atmospheric perspective use of shades of color and clarity to create the illusion of depth. Closer objects have warmer tones and clear outlines, while objects set further away are cooler and become hazy

Avant-garde early twentieth-century emphasis on artistic innovation, which challenged accepted values, traditions, and techniques

Balance a principle of art in which elements are used to create a symmetrical or asymmetrical sense of visual weight in an artwork

Bas-relief (**low relief**) a sculpture carved with very little depth: the carved subjects rise only slightly above the surface of the work

Classical (1) Greek art of the period *c.* 480–323 BCE; (2) ancient Greek and Roman; art that conforms to Greek and Roman models, or is based on rational constructions and emotional equilibrium

Collage a work of art assembled by gluing materials, often paper, onto a surface. From the French *coller*, to glue

Color the optical effect caused when reflected white light of the spectrum is divided into separate wavelengths

Complementary colors colors opposite one another on the color wheel

Composition the overall design or organization of a work

Conservator the person responsible for the care, restoration, and repair of the objects in a museum

Cropping trimming the edges of an image, or composing it so that part of the subject matter is cut off

Cross-hatching the use of overlapping parallel lines to convey darkness or lightness

Cubism, Cubist twentieth-century movement and style in art, especially painting, in which perspective with a single viewpoint was abandoned and use was made of simple geometric shapes, interlocking planes, and, later, collage; the Cubists were artists who formed part of the movement. "Cubist" is also used to describe their style of painting

Curator a person who organizes the collection and exhibition of objects/artworks in a museum or gallery

Decorative arts types of art that are concerned primarily with creation of such useful items as furniture, ceramics, and textiles

Docent a person who leads guided tours around a museum or gallery

Elements of art the basic vocabulary of art—line, form, shape, volume, mass, color, texture, space, motion and time, and value (lightness/darkness)

Emphasis the principle of drawing attention to particular content within a work

Facade any side of a building, usually the front or entrance

Focal point (1) the center of interest or activity in a work of art, often drawing the viewer's attention to the most important element; (2) the area in a composition to which the eye returns most naturally

Folk art the traditional, typically anonymous art of usually untrained people

Form an object that can be defined in three dimensions (height, width, and depth)

Geometric Predictable and mathematical

Golden Section a unique ratio of a line divided into two segments so that the sum of both segments (a + b) is to the longer segment (a) as the longer segment (a) is to the shorter segment (b). The result is 1:1.618

Happening impromptu art actions, initiated and planned by an artist, the outcome of which is not known in advance

Hatching the use of non-overlapping parallel lines to convey darkness or lightness

Heritage the traditions, achievements, and beliefs that are part of the history of a group or nation

Hierarchical scale the use of size to denote the relative importance of subjects in an artwork

High relief a carved panel where the figures project with a great deal of depth from the background

Hue general classification of a color; the distinctive characteristics of a color as seen in the visible spectrum, such as green or red

Implied line a line not actually drawn but suggested by elements in the work

Implied texture a visual illusion expressing texture

Impressionism a late nineteenth-century painting style conveying the impression of the effects of light; Impressionists were painters working in this style

In the round a freestanding sculpted work that can be viewed from all sides

Isometric perspective a system using diagonal parallel lines to communicate depth

Kinetic art three-dimensional art that moves, impelled by air currents, motors, or people

Line a mark, or implied mark, between two endpoints

Linear perspective a system using converging imaginary sight lines to create the illusion of depth

Mass a volume that has, or gives the illusion of having, weight, density, and bulk

Medium (plural **media**) the material on or from which an artist chooses to make a work of art

Monochromatic having one or more values of one color

Motif (1) a design or color repeated as a unit in a pattern; (2) a distinctive visual element, the recurrence of which is often characteristic of an artist's work

Motion the effect of changing placement in time

Negative space an unoccupied or empty space that is created after positive shapes are positioned in a work of art

One-point perspective a perspective system with a single vanishing point on the horizon

Optical mixture when the eye blends two colors that are placed near each other, creating a new color

Organic having irregular forms and shapes, as though derived from living organisms

Orthogonals in perspective systems, imaginary sightlines extending from forms to the vanishing point

Pattern an arrangement of predictably repeated elements

Performance art a work involving the human body, usually including the artist, for an audience

Perspective the creation of the illusion of depth in a two-dimensional image by using mathematical principles

Plane a flat, two-dimensional surface on which an artist can create a drawing or painting. Planes can also be implied in a composition by areas that face towards, parallel to, or away from a light source

Positive shape a shape defined by its surrounding empty space

Post-and-lintel construction a horizontal beam (the lintel) supported by a post at either end

Principles the principles, or "grammar" of art—contrast, balance, unity, variety, rhythm, emphasis, pattern, scale, proportion, and focal point—describe the ways the elements of art are arranged in an artwork

Proportion the relationship in size between a work's individual parts and the whole

Rhythm the regular or ordered repetition of elements in the work

Scale the size of an object or an artwork relative to another object or artwork, or to a system of measurement

Self-taught art art produced by people who have acquired their knowledge and skills by their own efforts, rather than through formal education

Shape a two-dimensional area, the boundaries of which are defined by lines or suggested by changes in color or value

Space the distance between identifiable points or planes

Style a characteristic way in which an artist or group of artists uses visual language to give a work an identifiable form of visual expression

Subordination the opposite of emphasis; it draws our attention away from particular areas of a work

Texture the surface quality of a work, for example fine/coarse, detailed/lacking in detail

Three-dimensional having height, width, and depth

Two-dimensional having height and width

Unity the appearance of oneness or harmony in a work of art: all of the elements appearing to be part of a cohesive whole

Value the lightness or darkness of a plane or area

Vanishing point the point or points in a work of art at which imaginary sight lines appear to converge, suggesting depth

Variety the diversity of different ideas, media, and elements in a work

Volume the space filled or enclosed by a three-dimensional figure or object

NOTES AND SKETCHES

NOTES AND SKETCHES